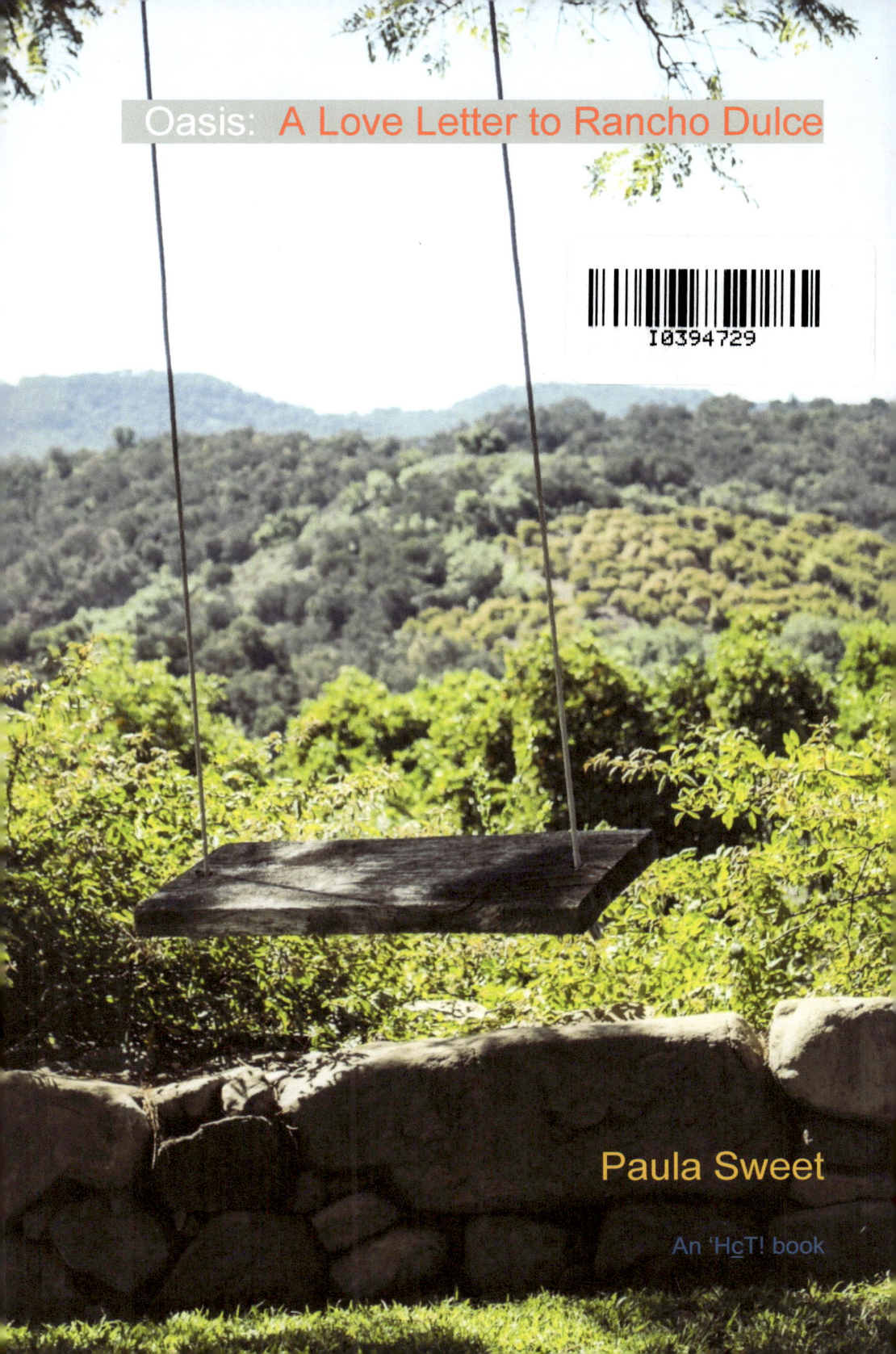

Oasis: A Love Letter to Rancho Dulce

Text and photography ©2016 by Paula Sweet
ISBN 9781533139870
First edition May 2016

Designed by SMoss

An 'HcT! Book

This book is dedicated to
Pamela and Richard
who created Eden

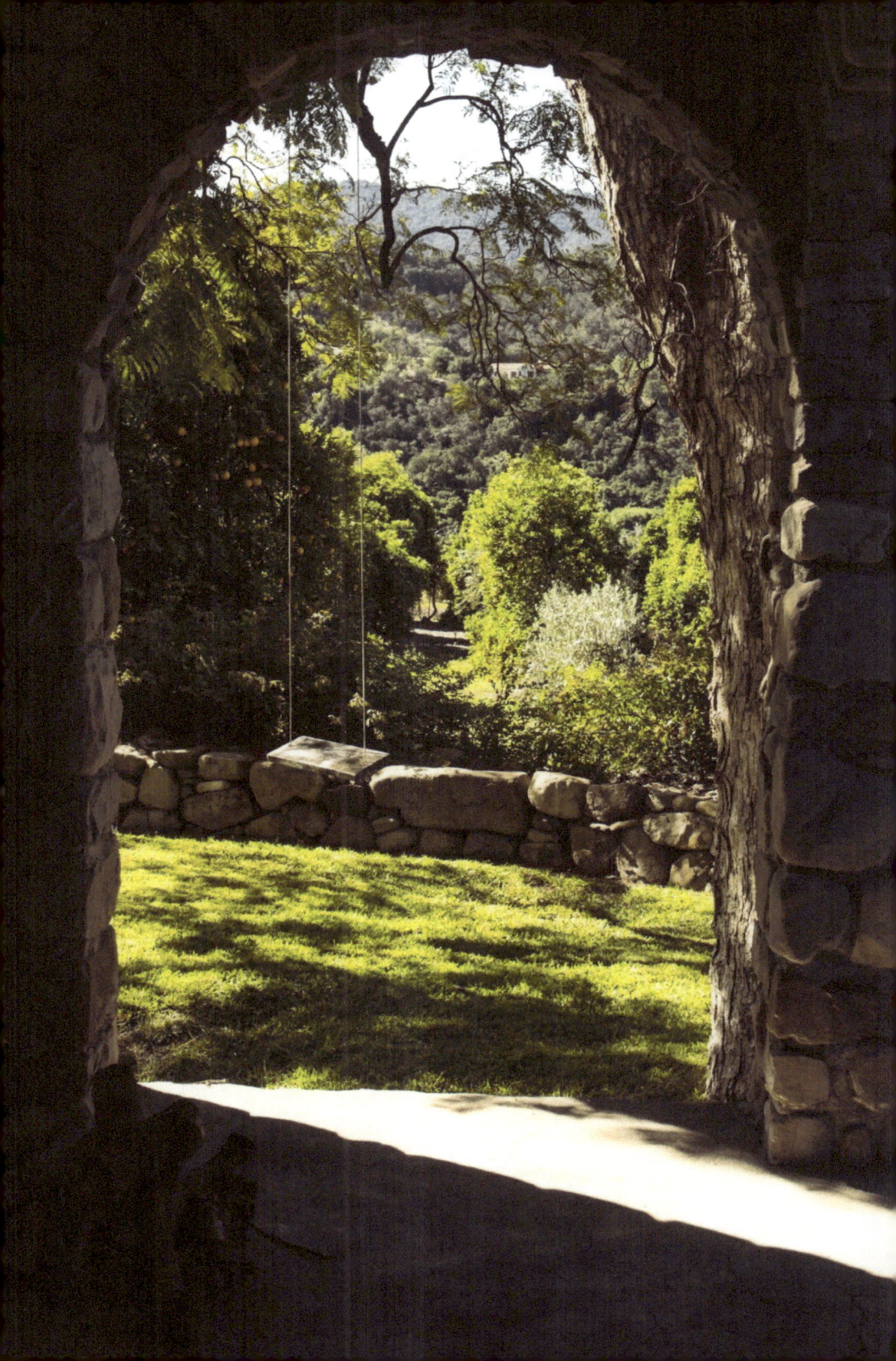

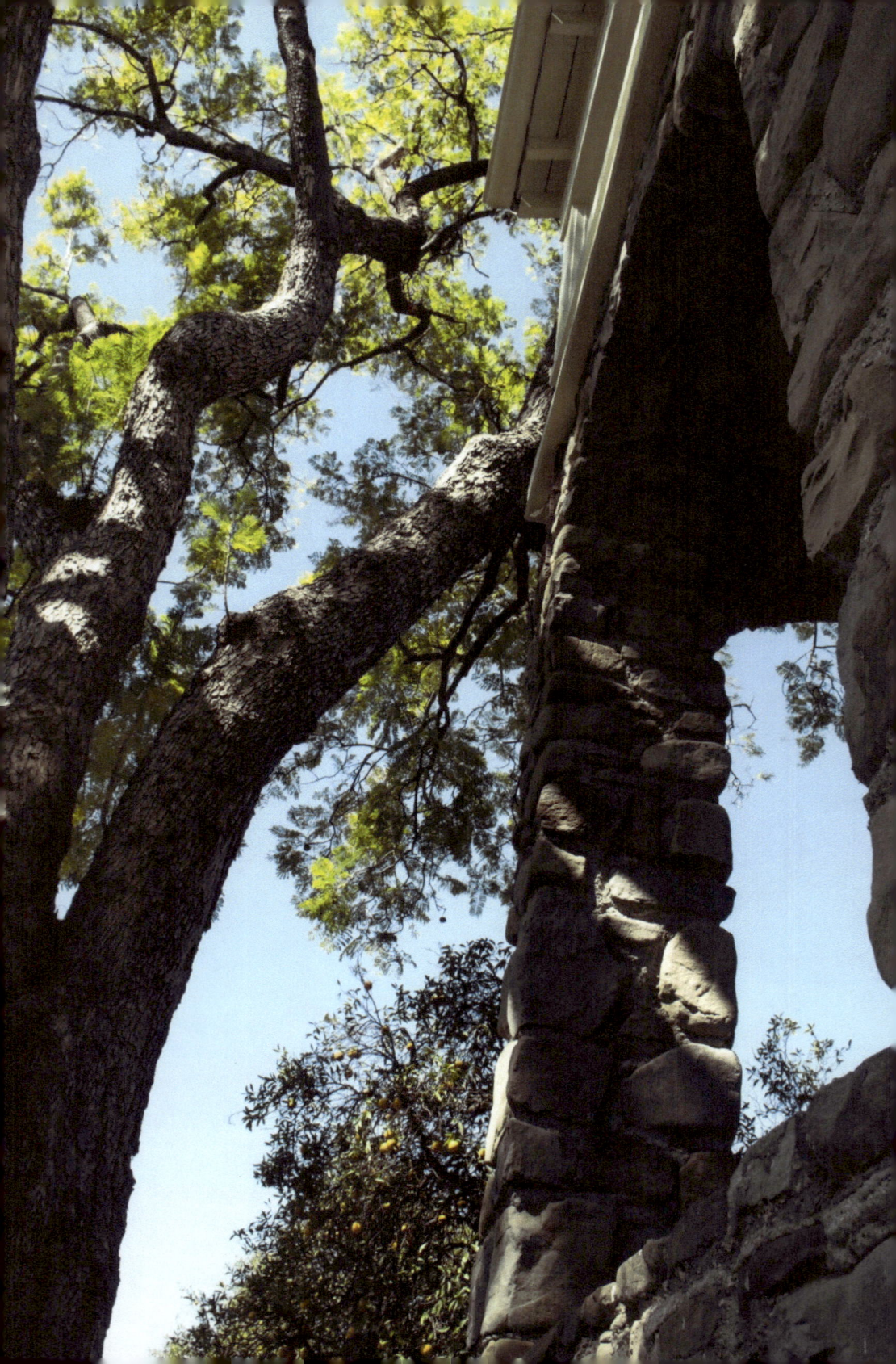

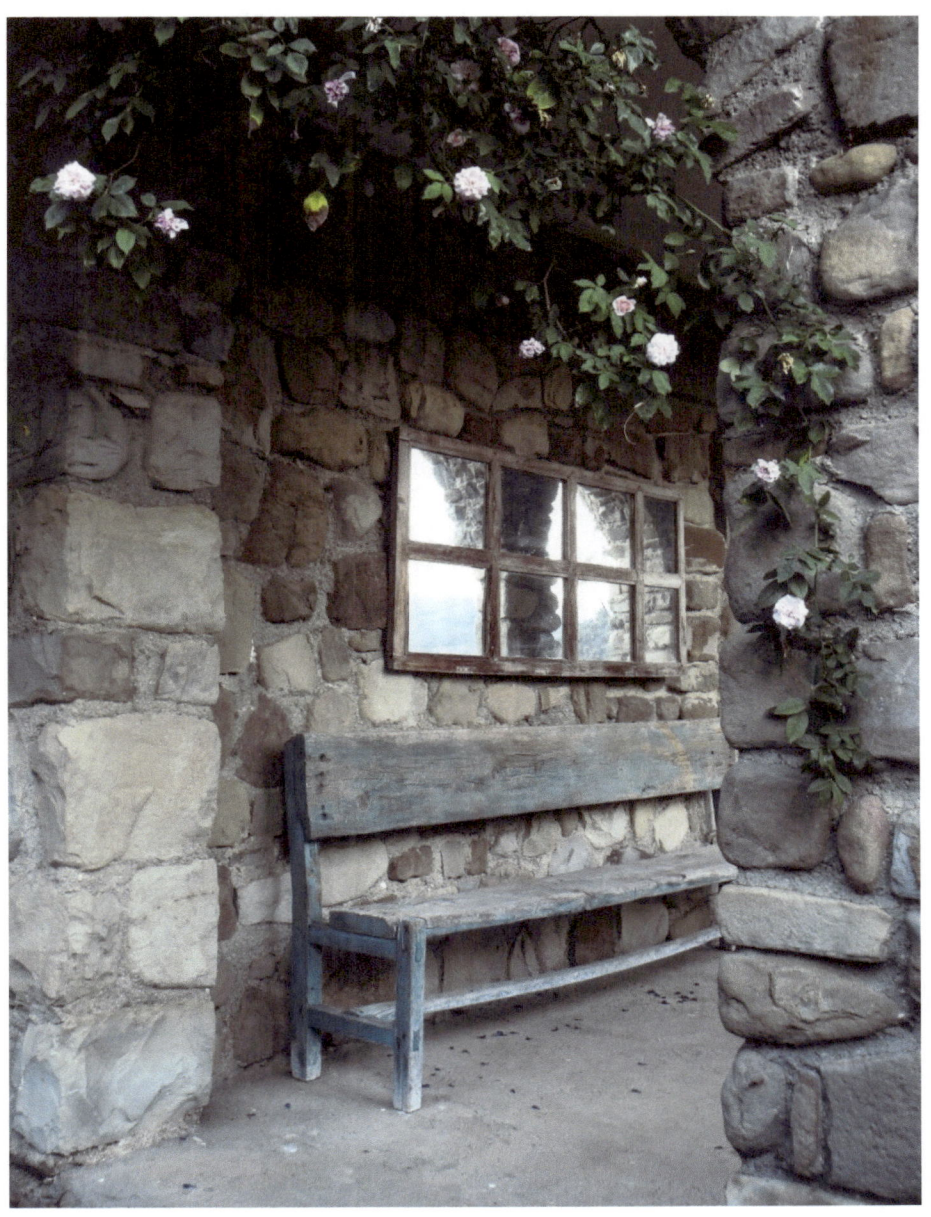

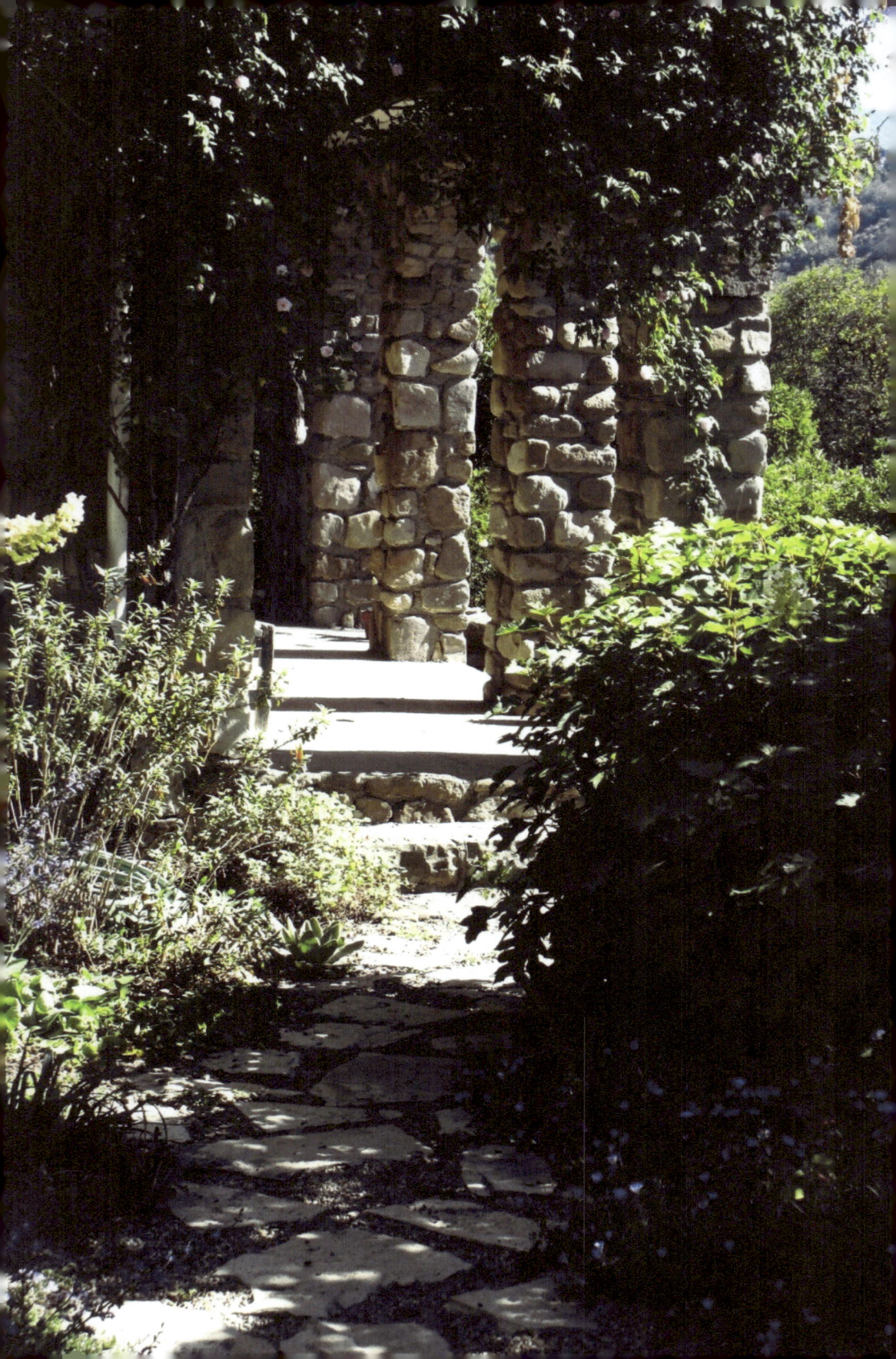

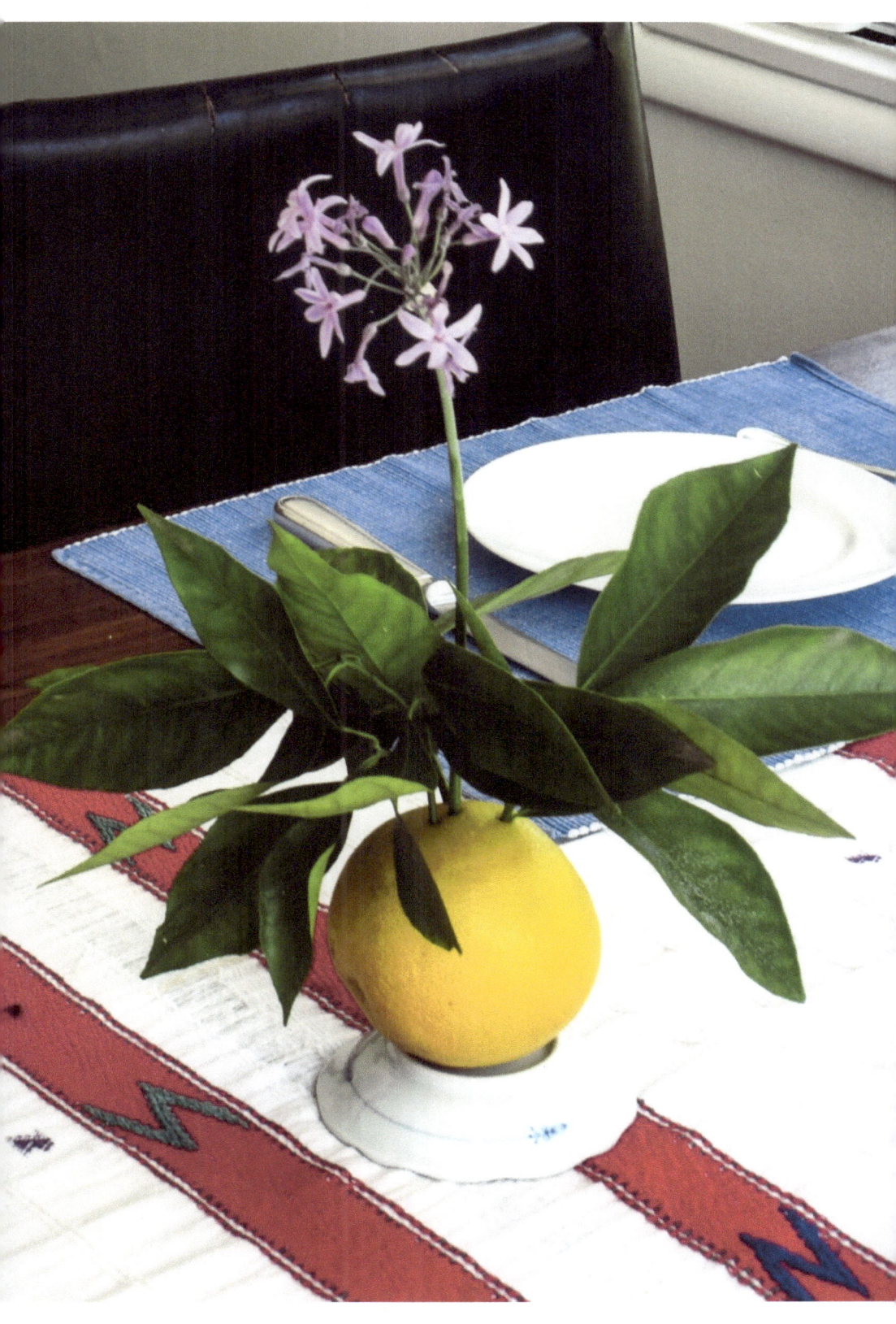

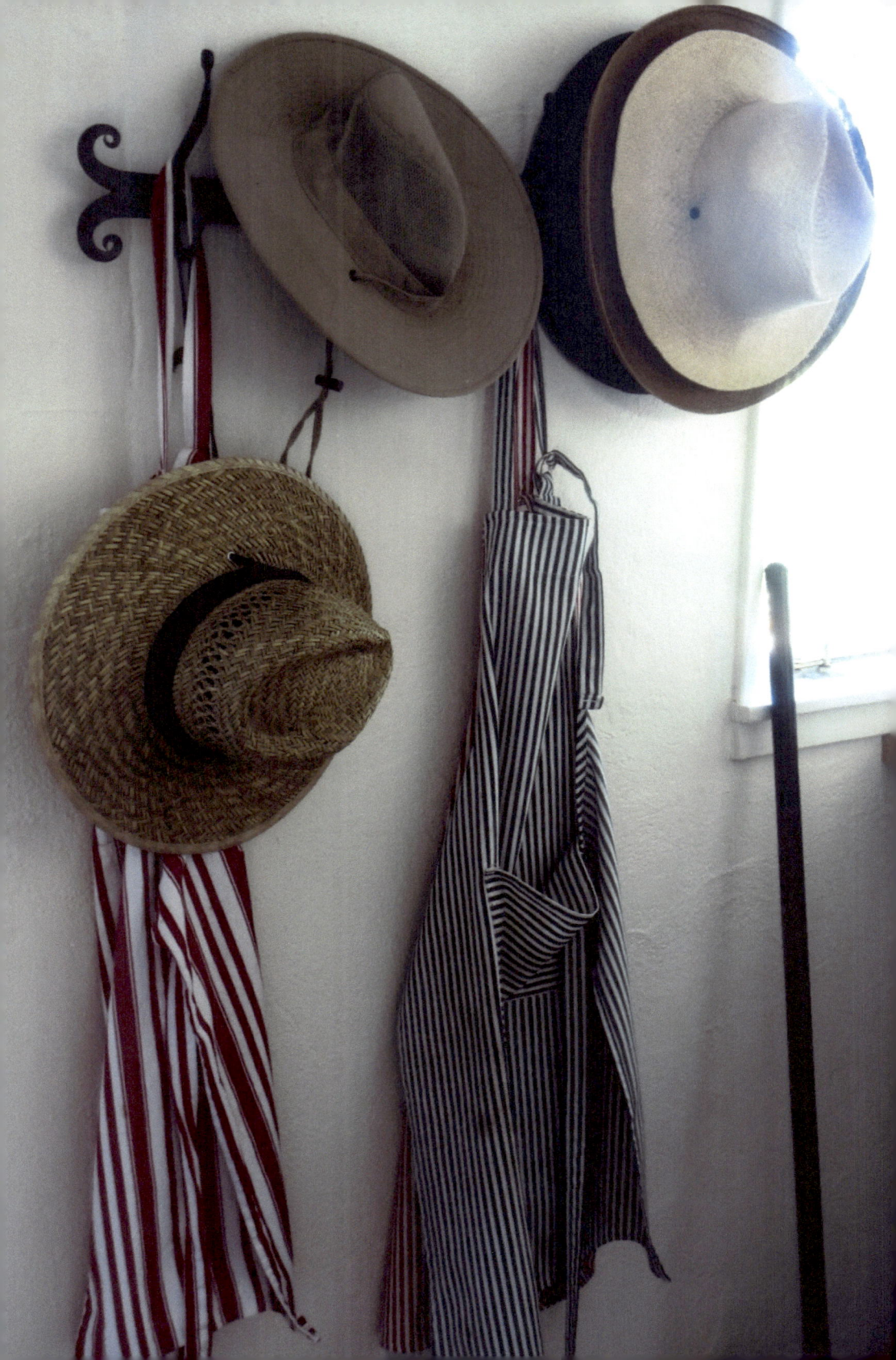

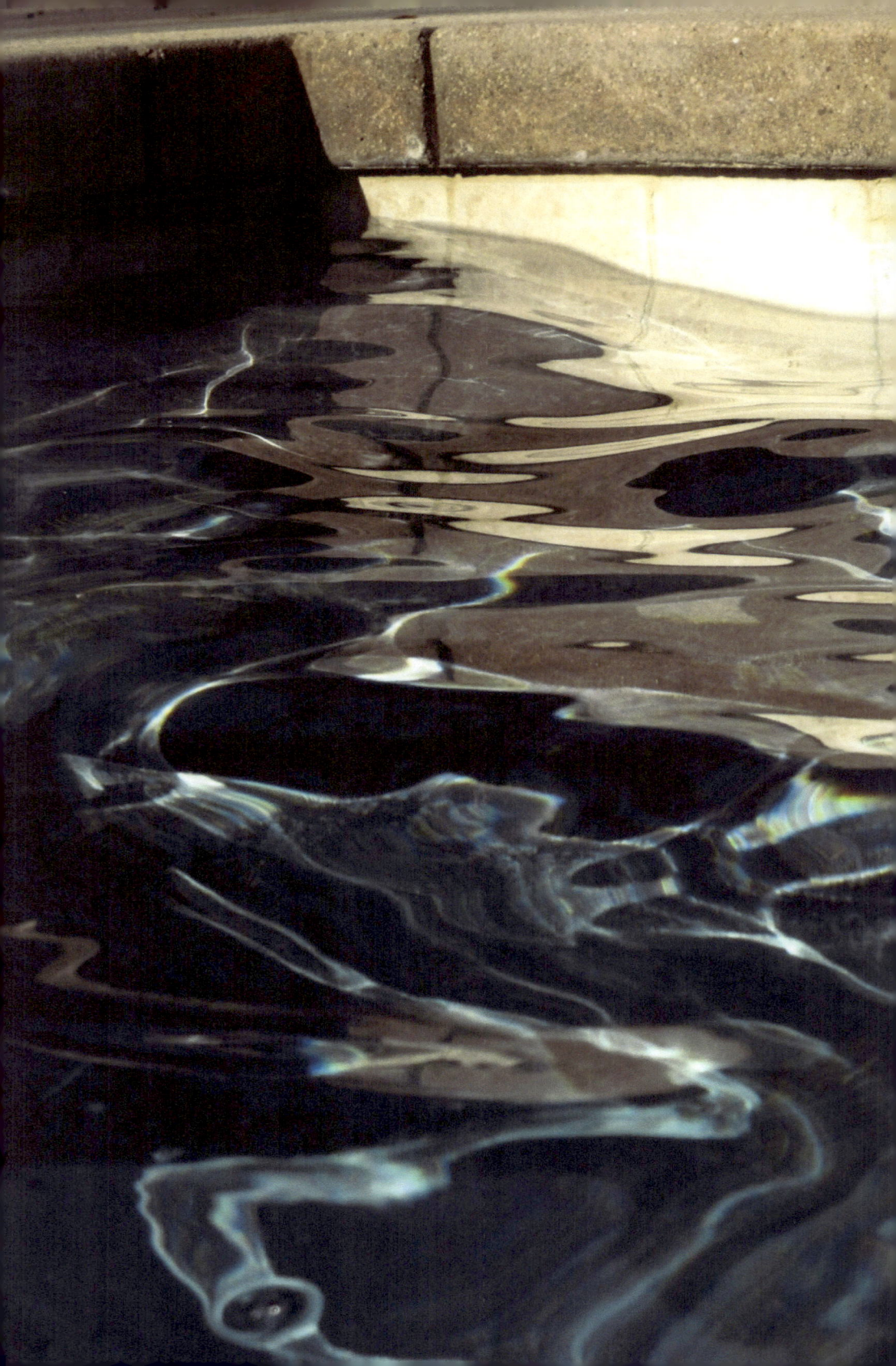

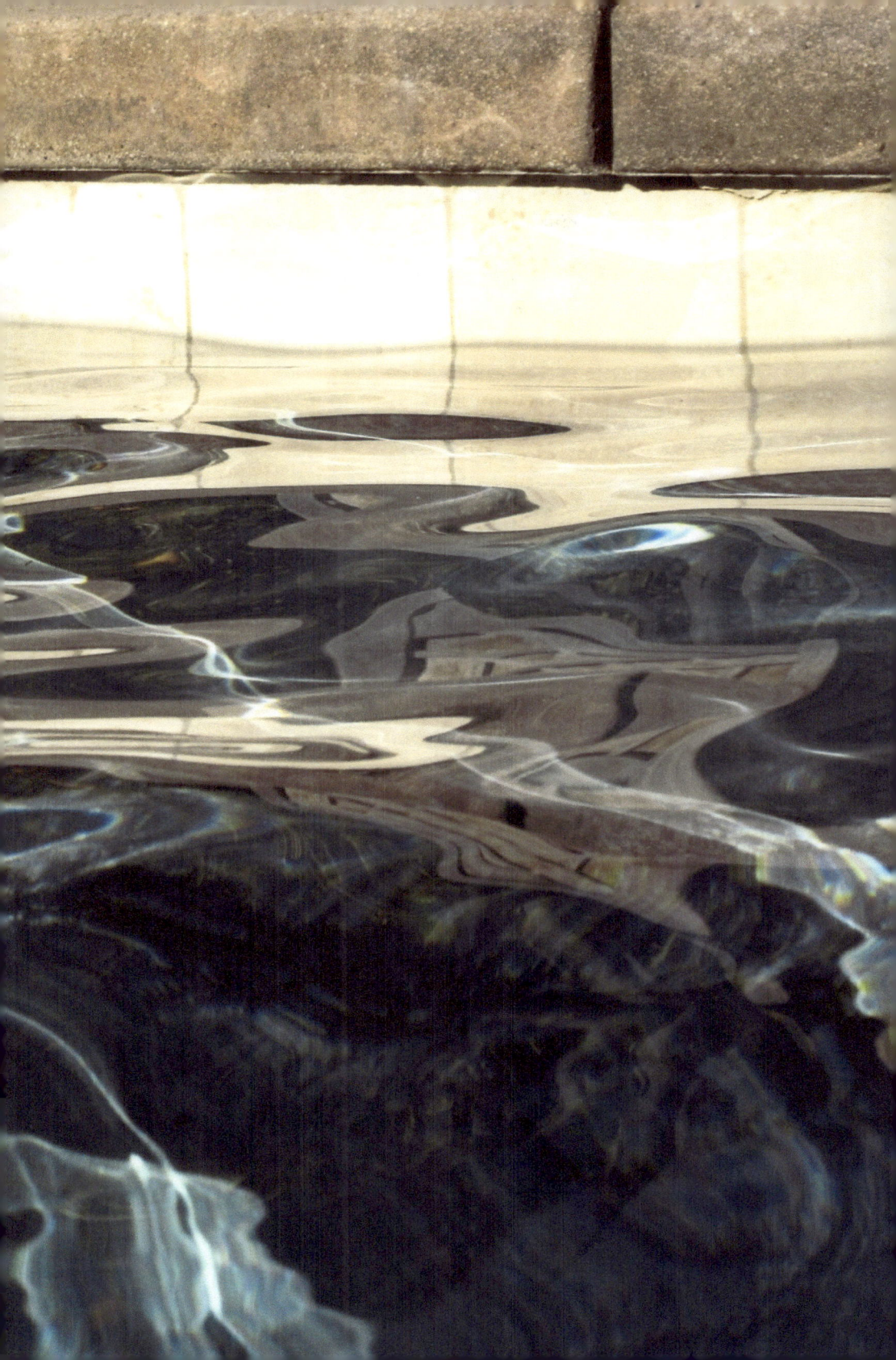

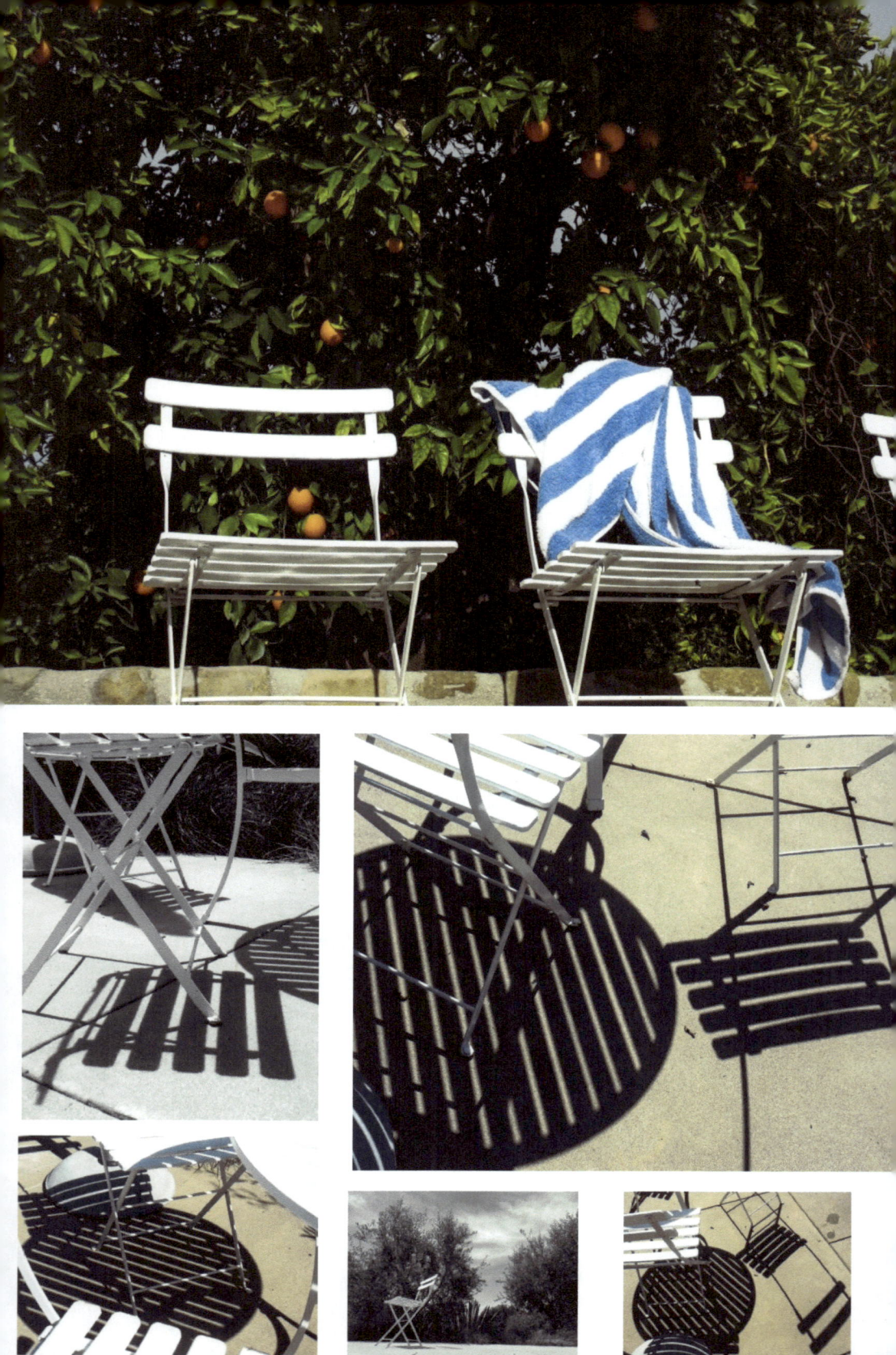

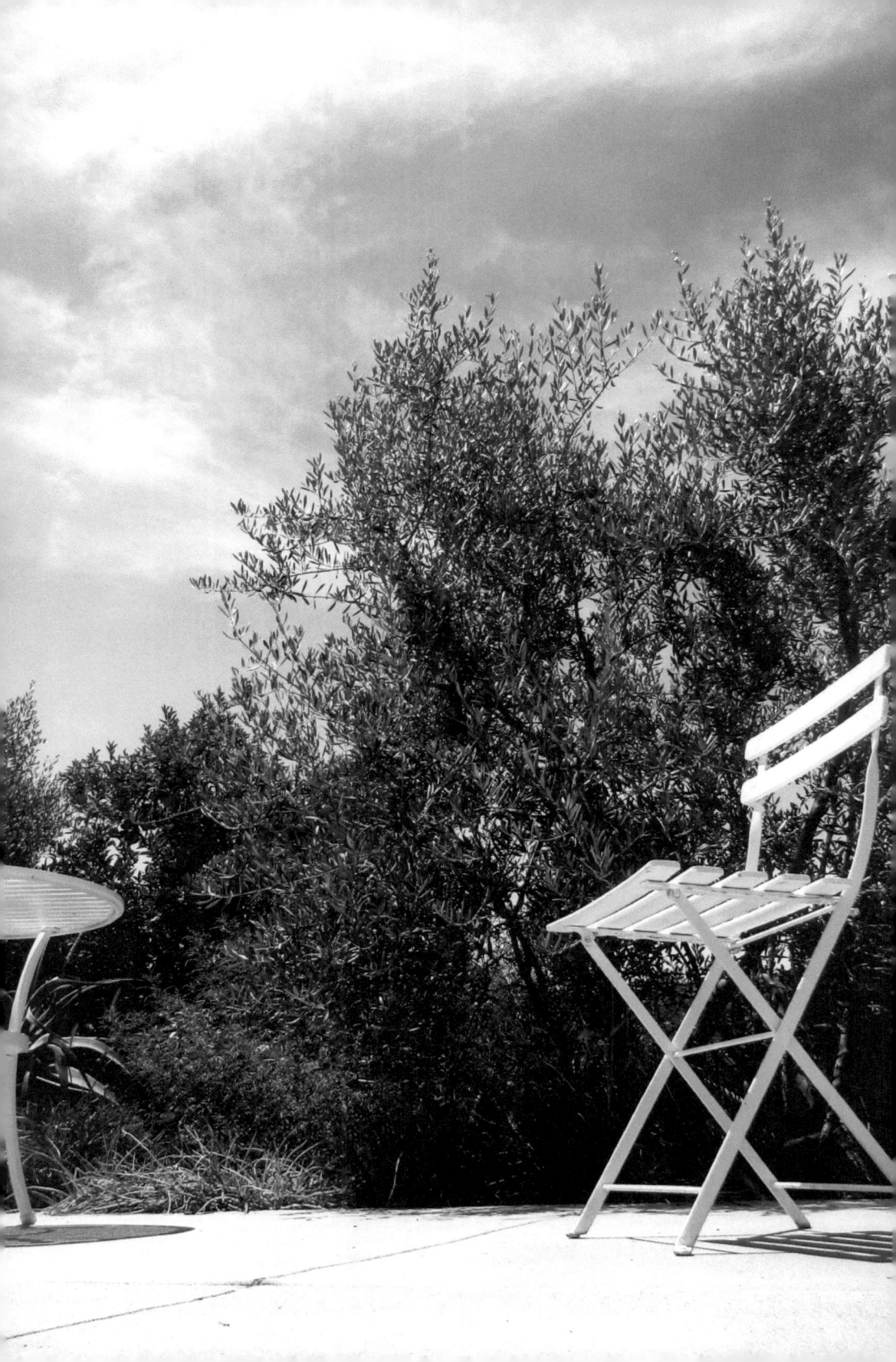

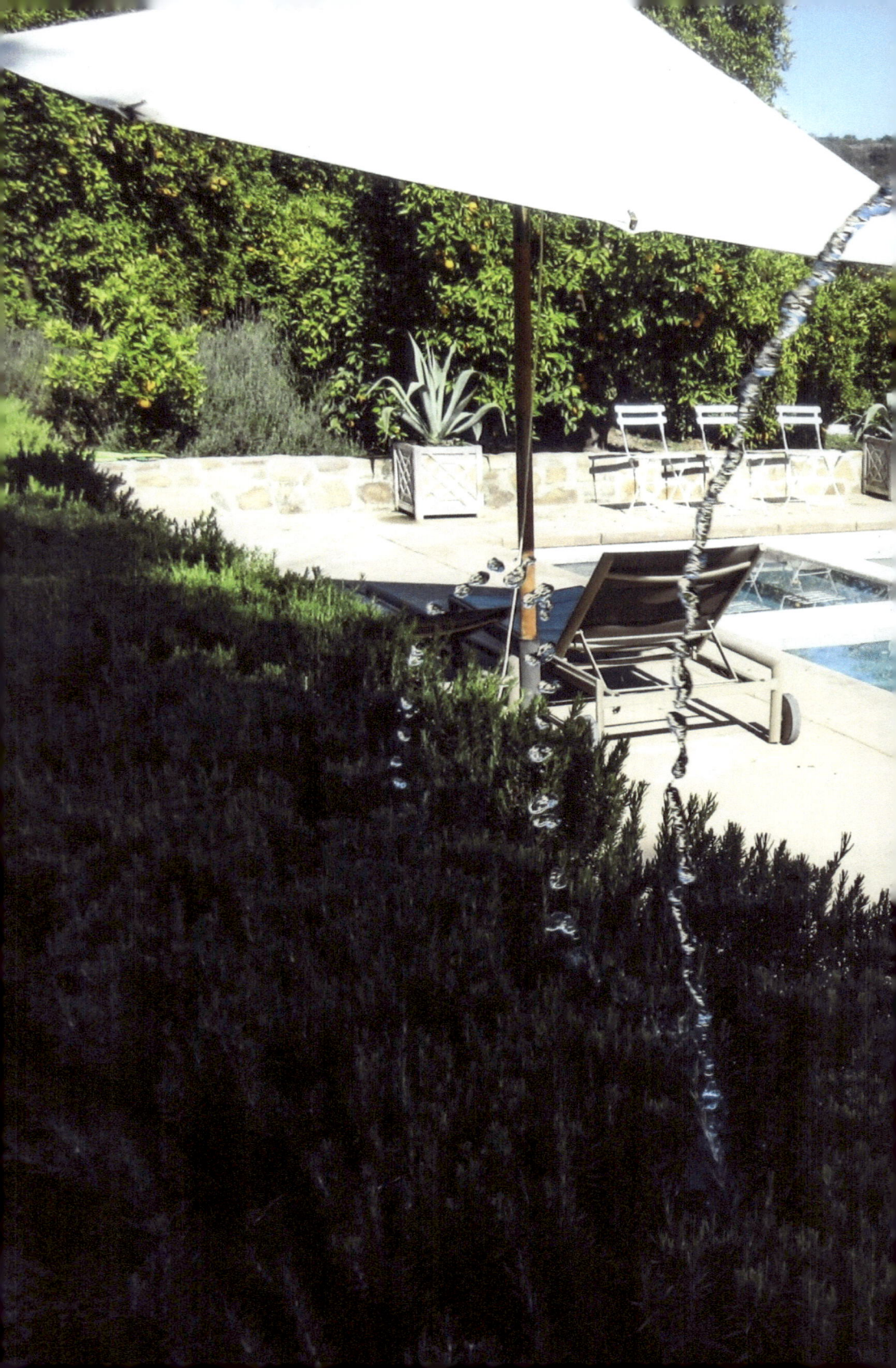

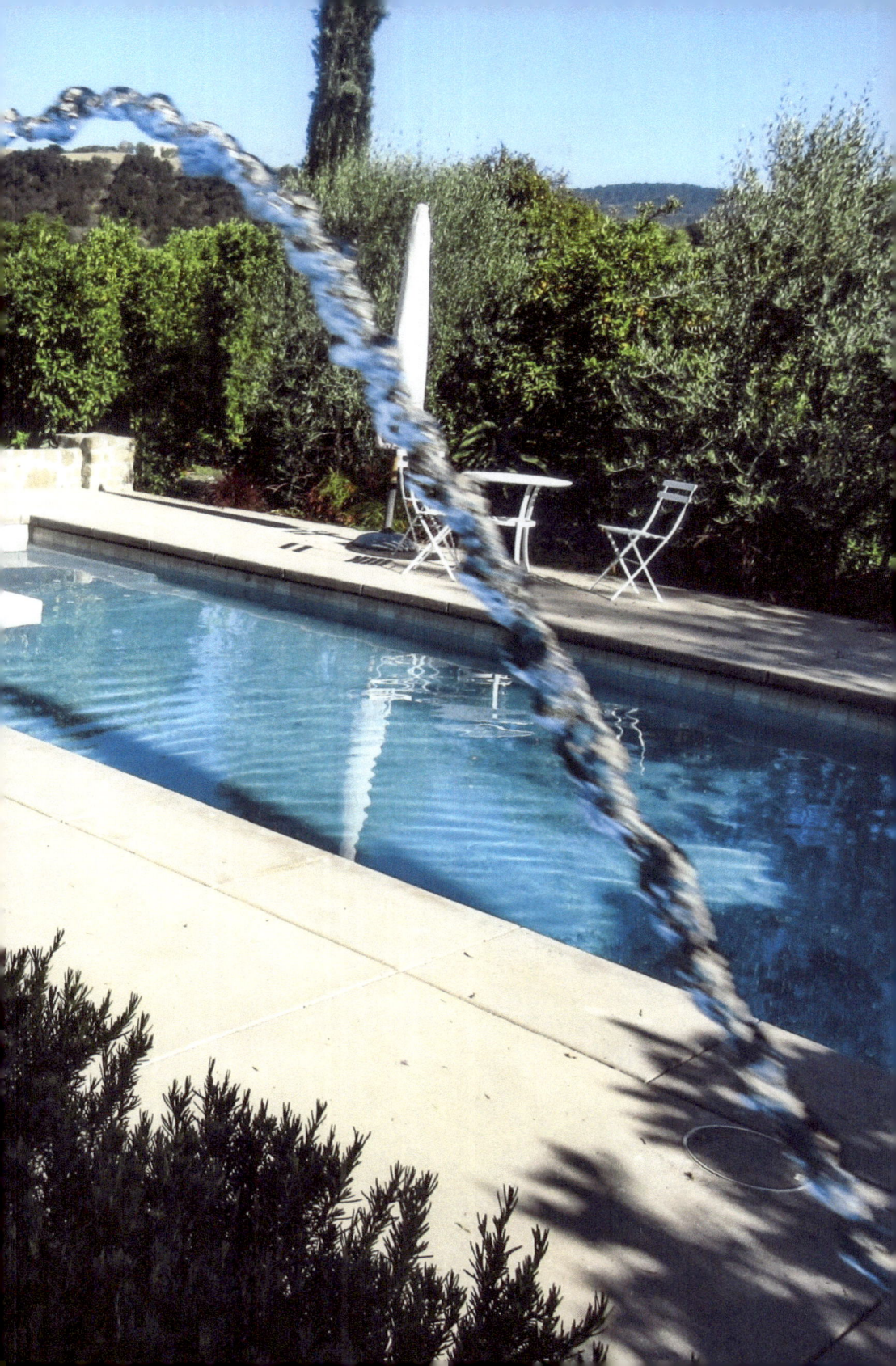

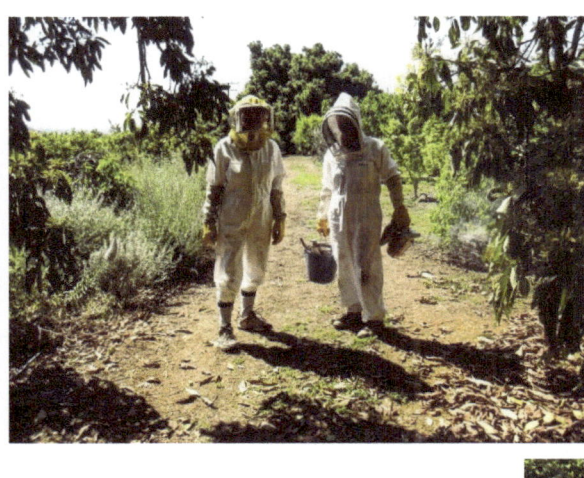
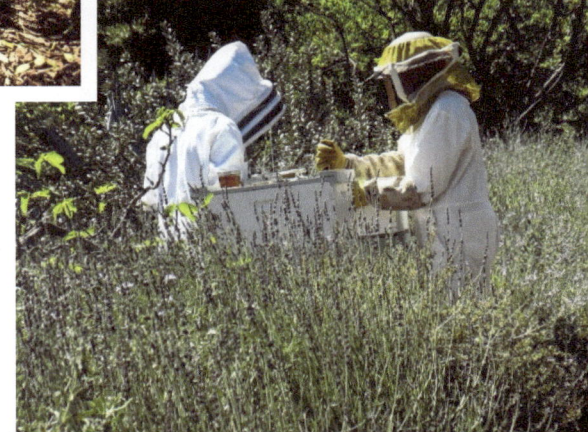

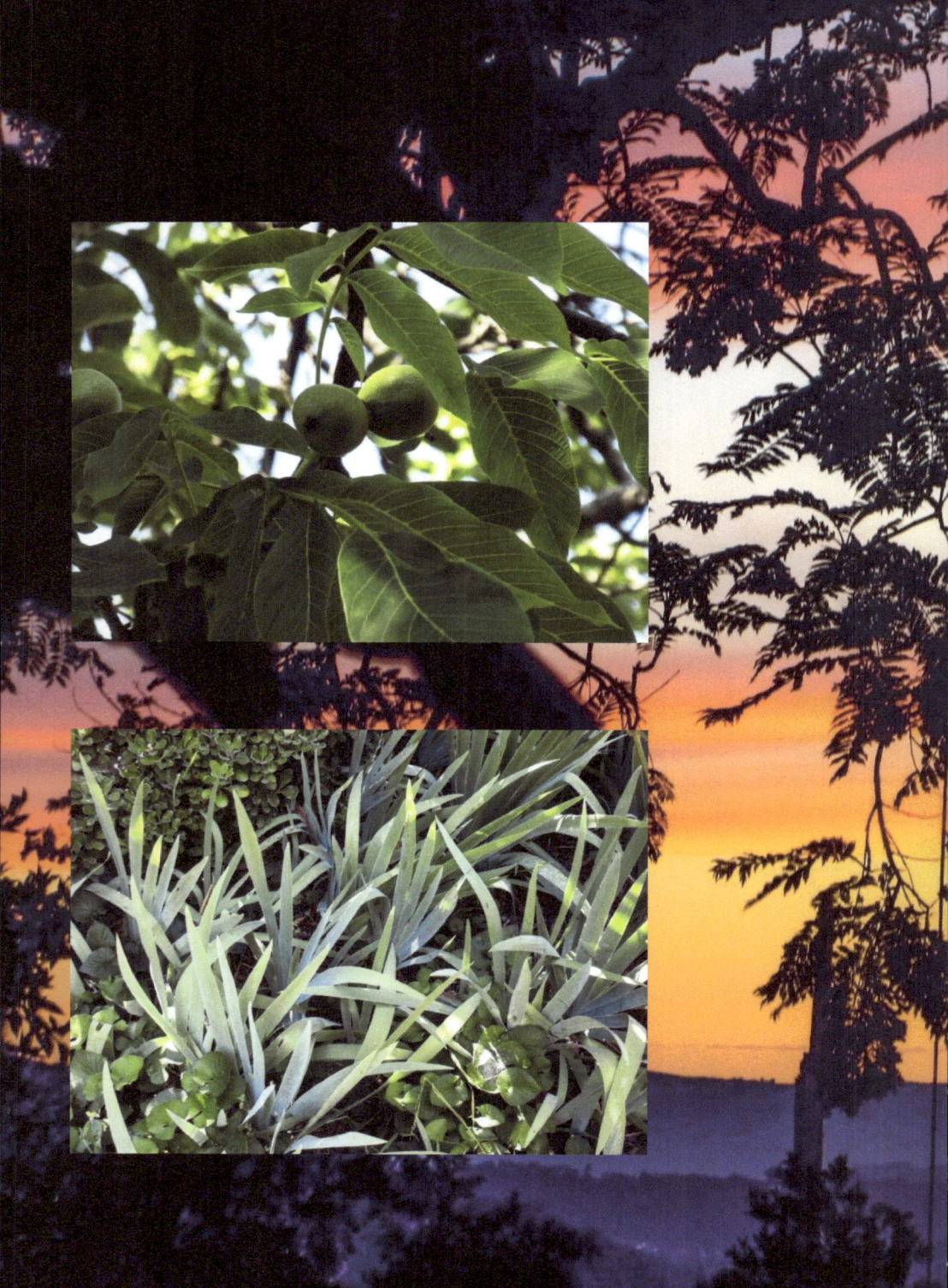

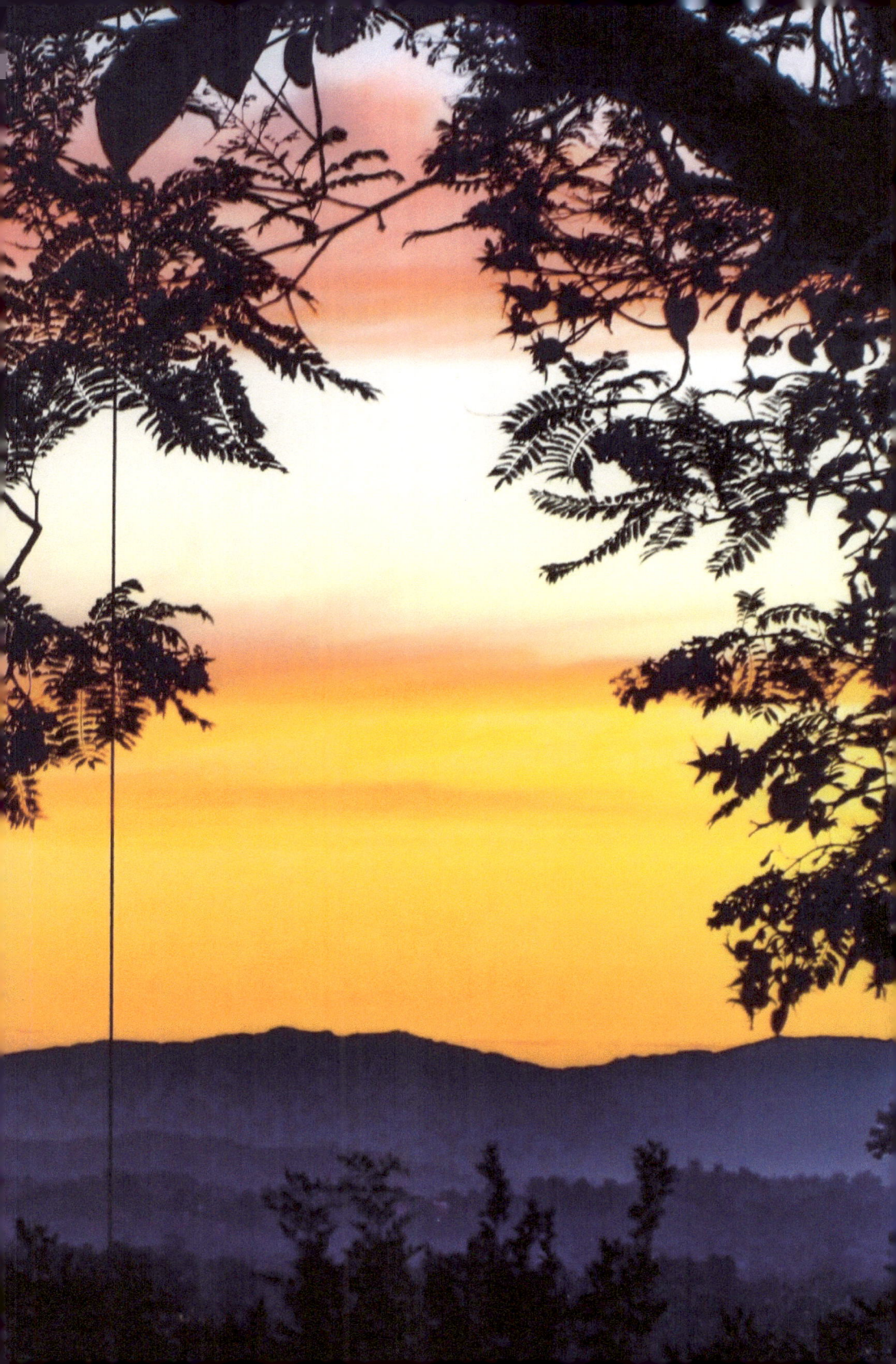

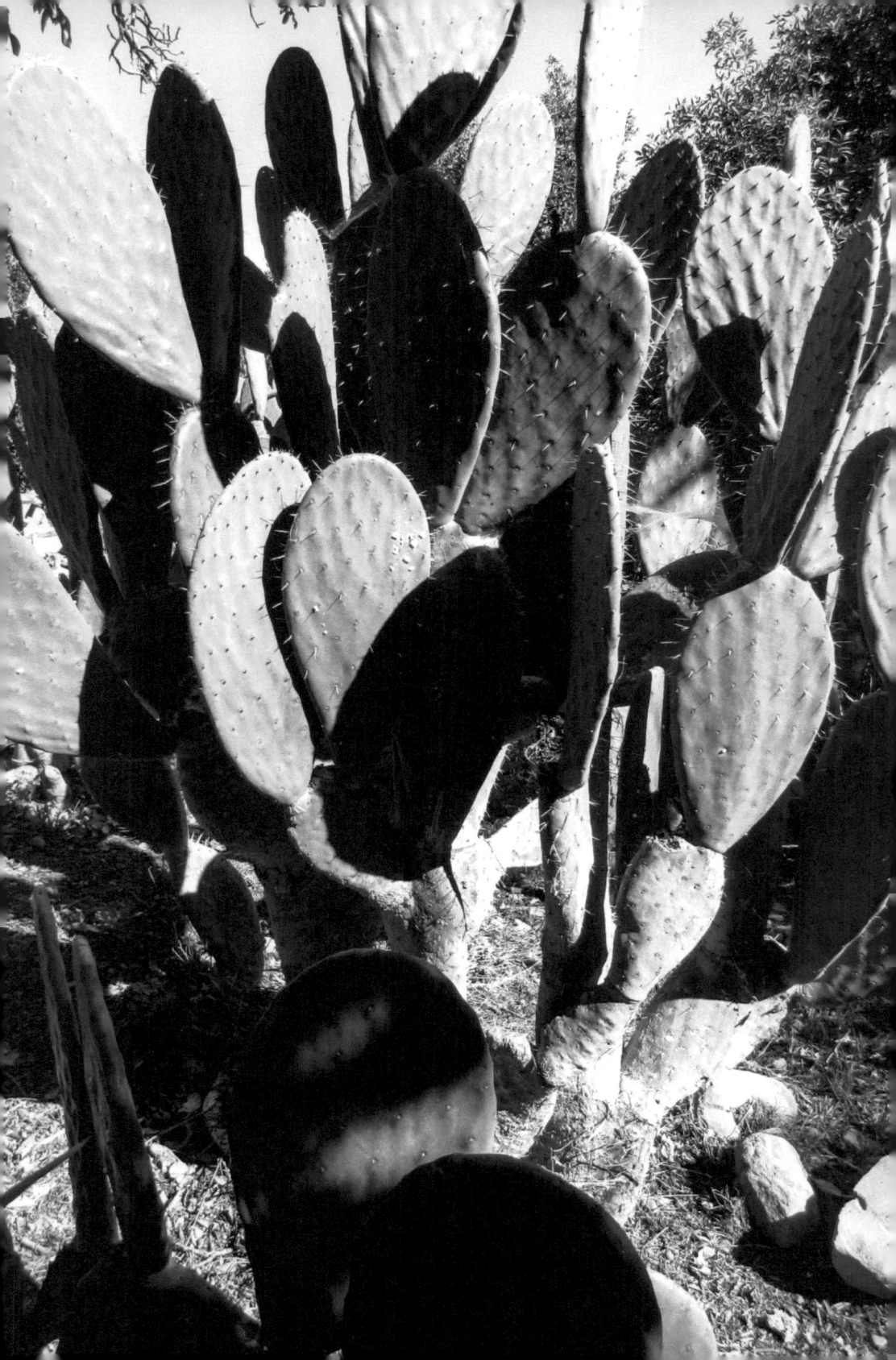

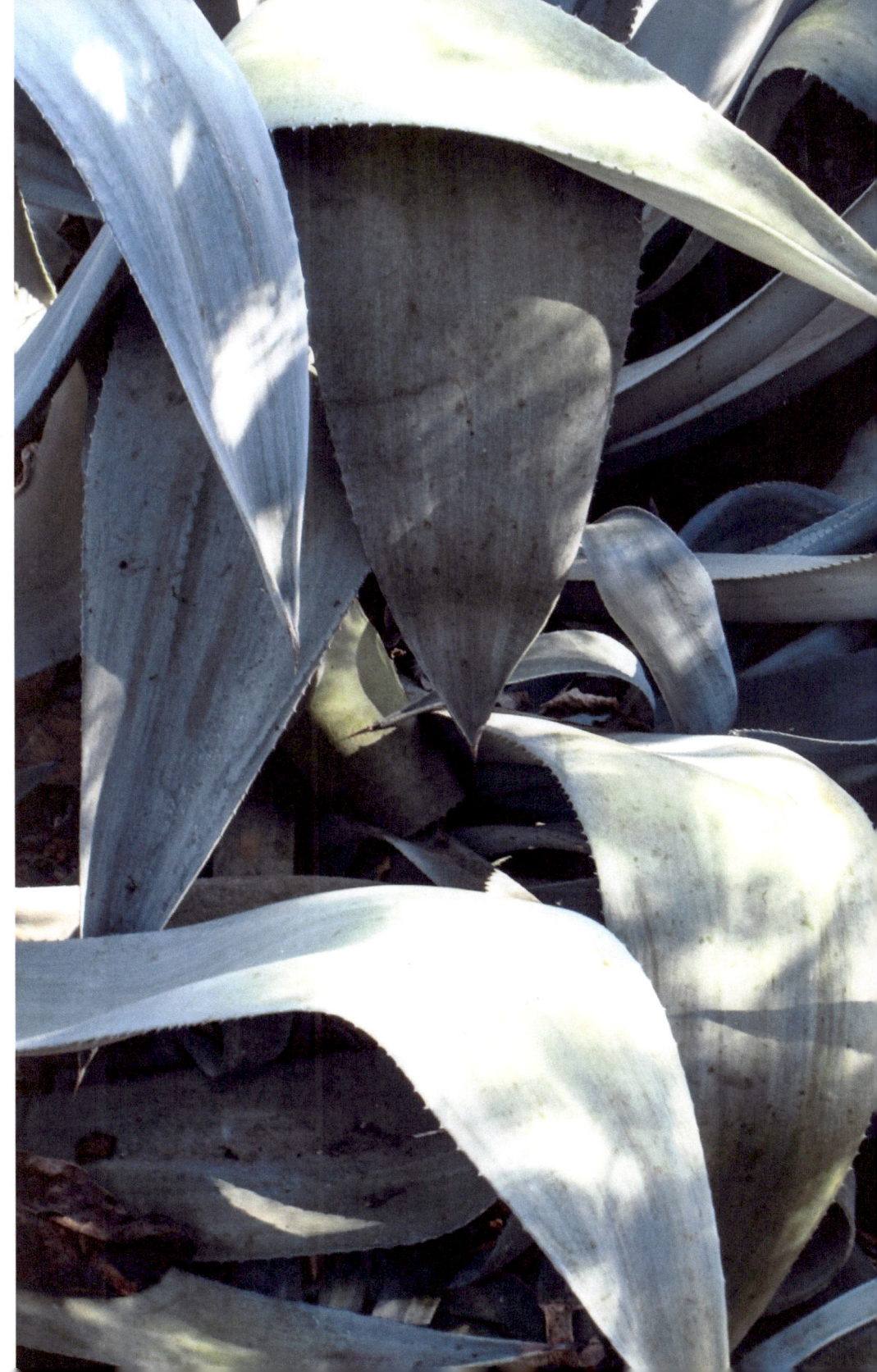

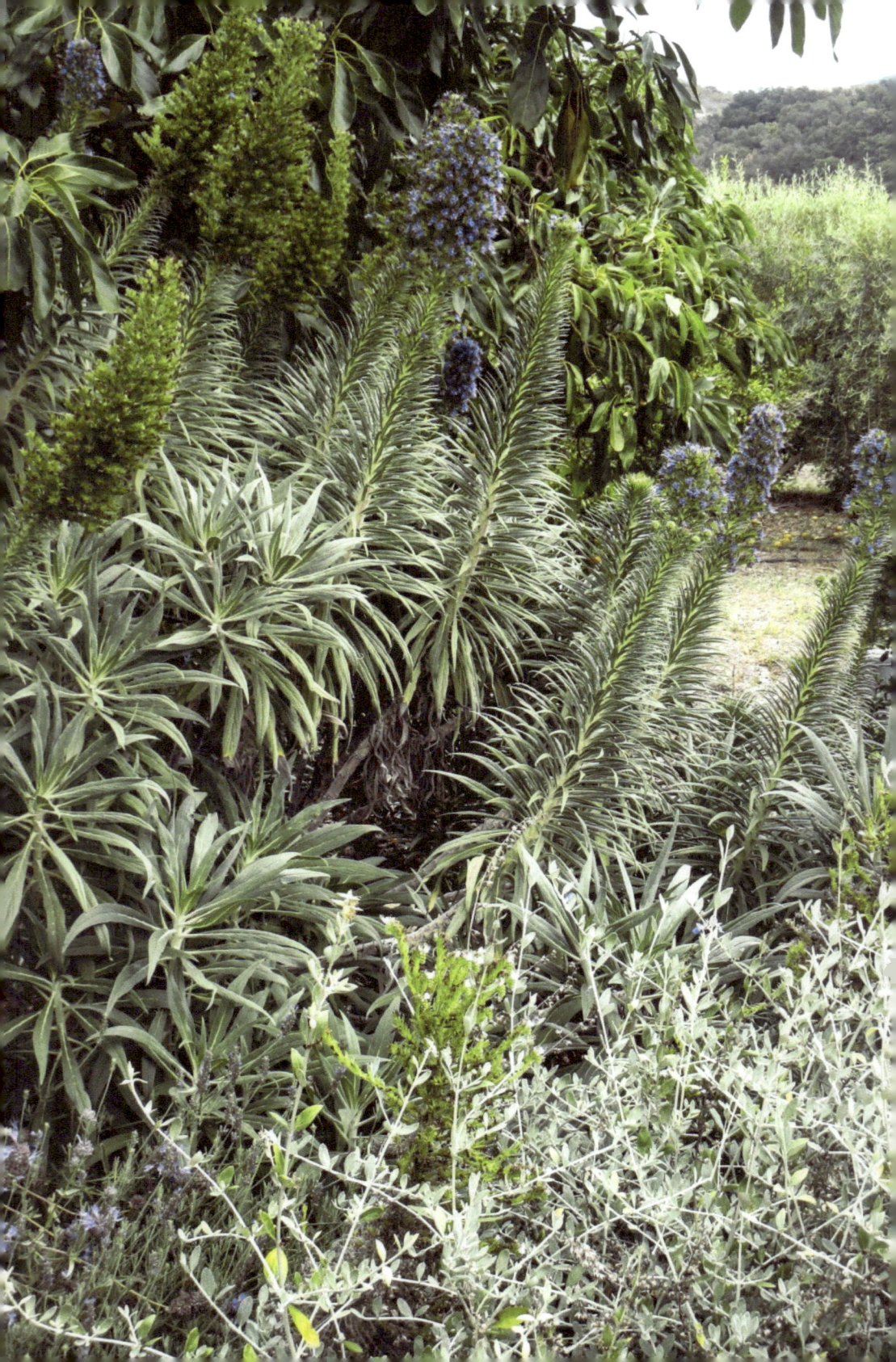

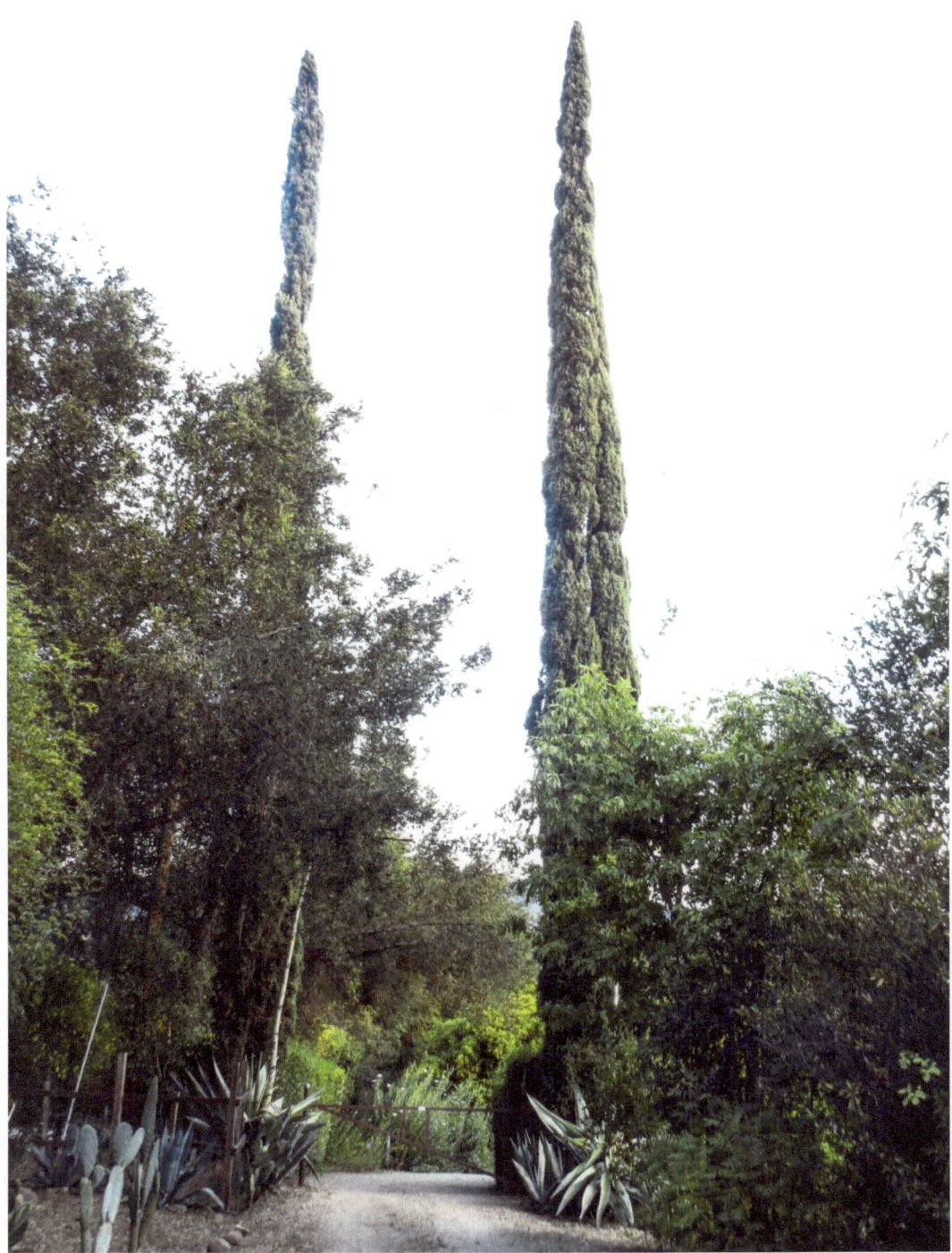

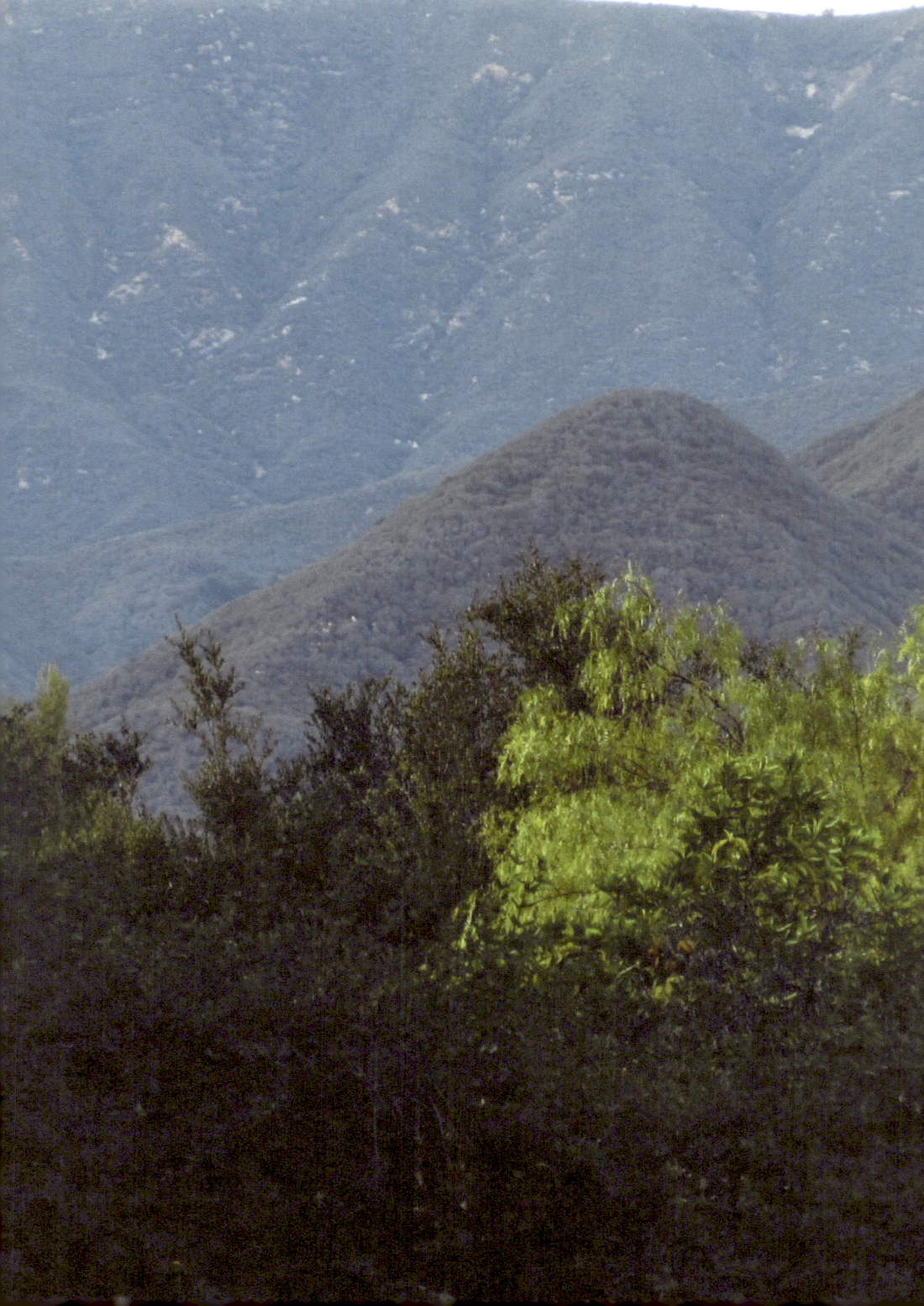

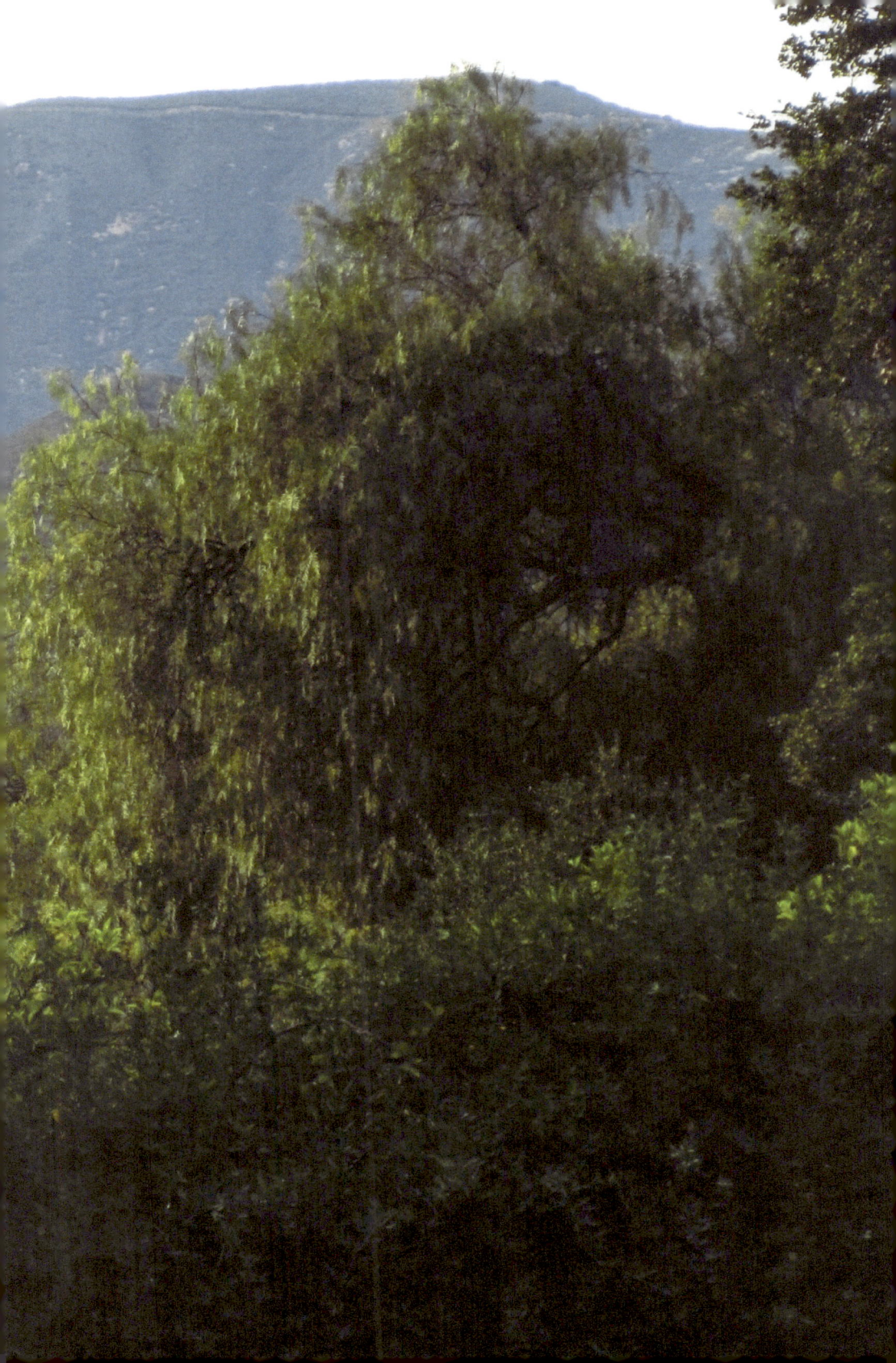

Have you seen these other books by Paula Sweet?:

The Love Letters
Avanti: *A Love Letter to Ministero del Gusto*
Return to Paradise: *A Love Letter to Catalina*

DO NOT – *a book of rules*

The Grandpa Trio
Grandpa Goes Shopping
Grandpa Does Yoga
Grandpa Takes A Walk

Paula's Proverbs, Volume I
Paula's Proverbs, Volume II

VSB

The Vicentini

and check out these titles from 'HcT! Press:

111 Haikus

2014 Global Brand Letter
2015 Global Brand Letter

24 Poems by Marco Fazzini

The Blue Tibetan Poppy

The Book of Deals

Case Studies of Five Modern Labyrinths

The Captain Blackpool Trilogy
The Crimson Garter
Fate & the Pearls

The History & Adventures of the
Bandit Joaquin Murietta

Hitman in Delhi, *a screenplay*

La Toux

Leaving Your Dragon

Legacy & Power

Park Avenue Poop

Supari

Surf City: *A Love Letter to Santa Teresa*

Swami Gopal Buri

Time Out For Dragon!

What Is A Brand?

www.ingramcontent.com/pod-product-compliance
Lightning Source LLC
Chambersburg PA
CBHW040921180526
45159CB00002BA/556